Strange Little Designs

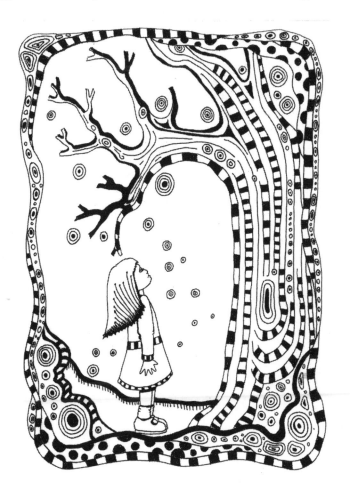

A MINI COLORING BOOK ADVENTURE

Drawings by

Kimberly Garvey

This book is dedicated to my favorite travel companions: Patrick Garvey,

Cassidy Atkins, and Nathaniel Atkins.

IF YOU ARE COLORING

WITH MARKERS,

please put a protection sheet of
paper between the pages to
prevent bleed-through.

Protection sheet provided at the
end of this book.

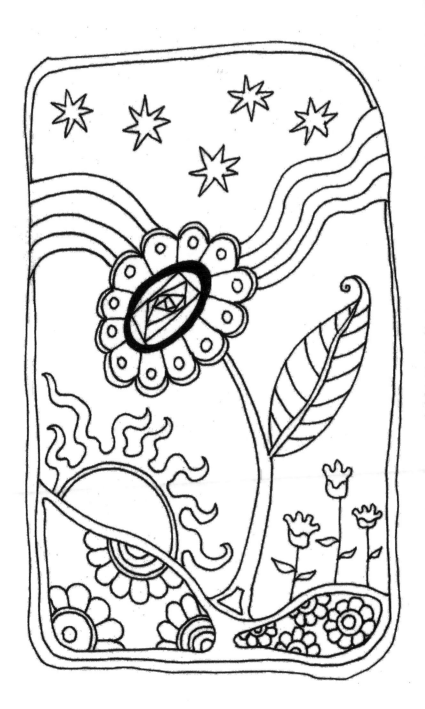

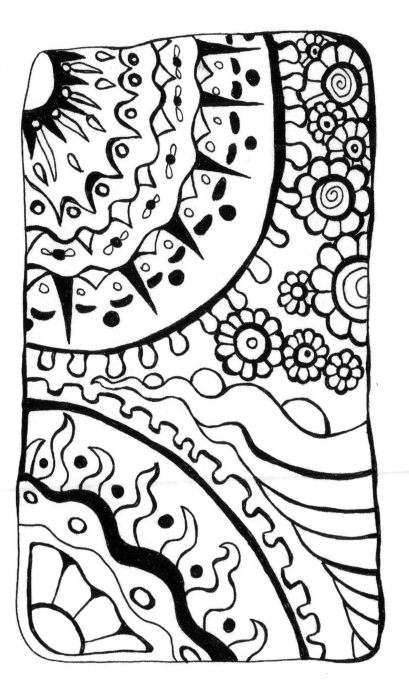

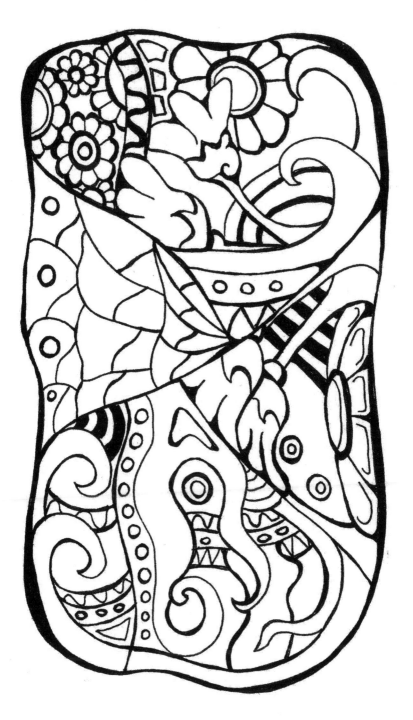

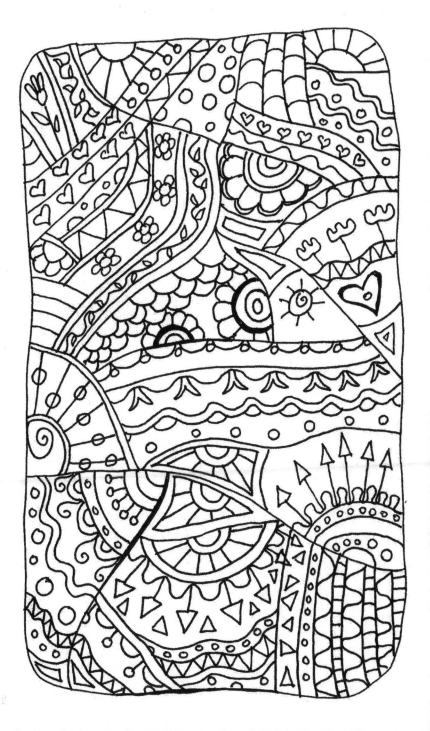

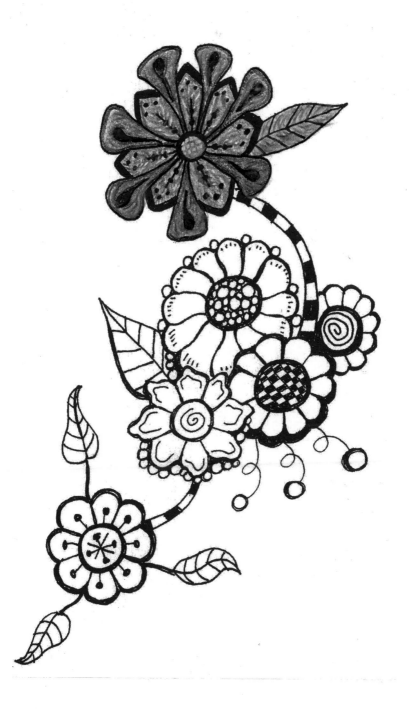

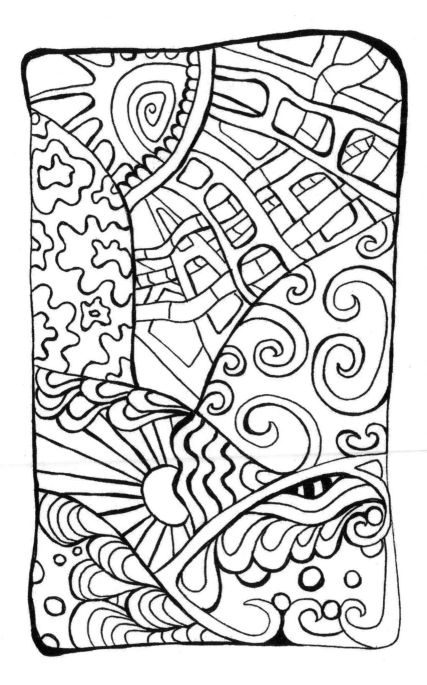

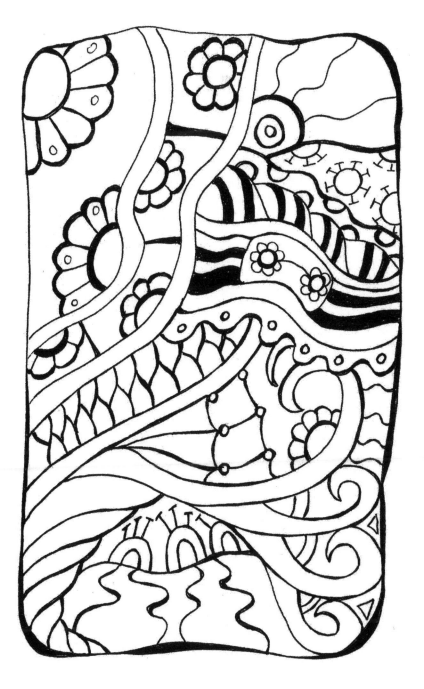

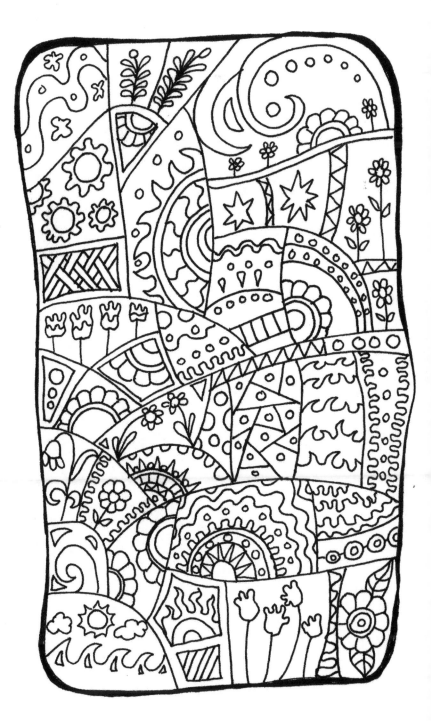

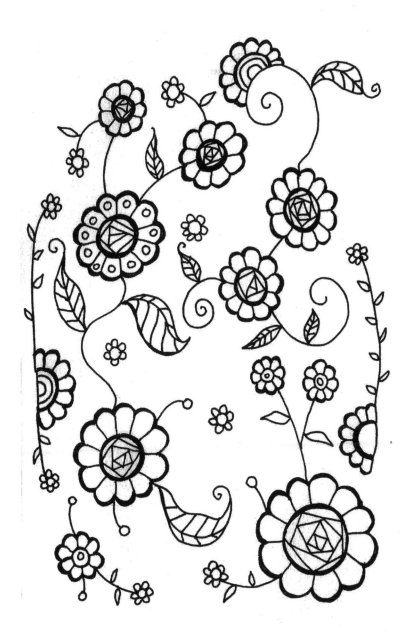

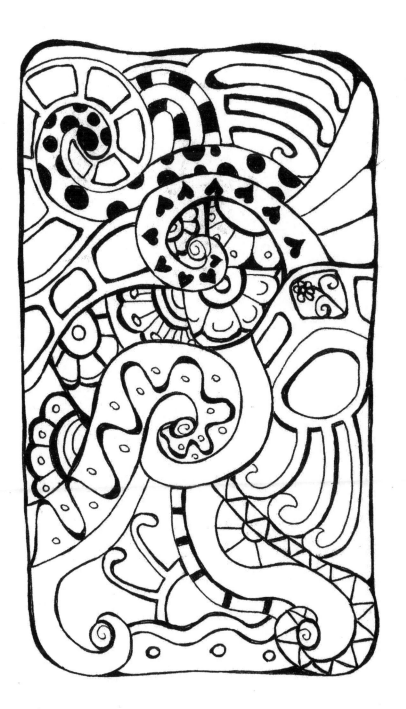

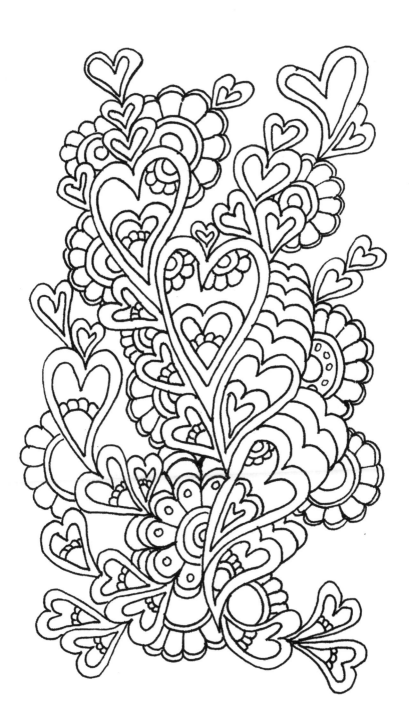

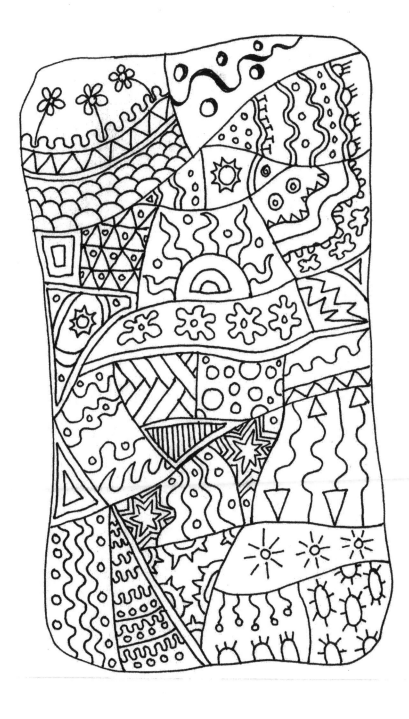

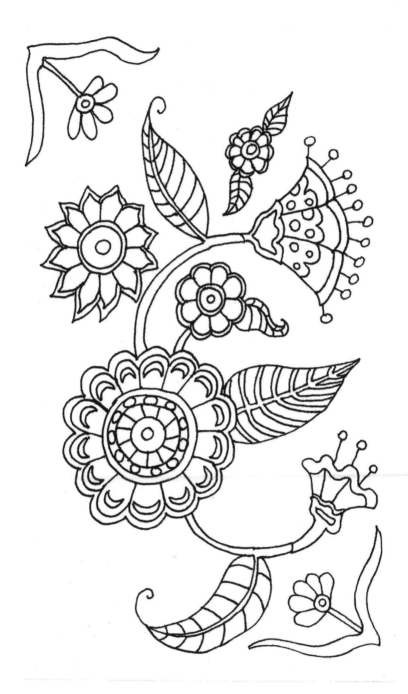

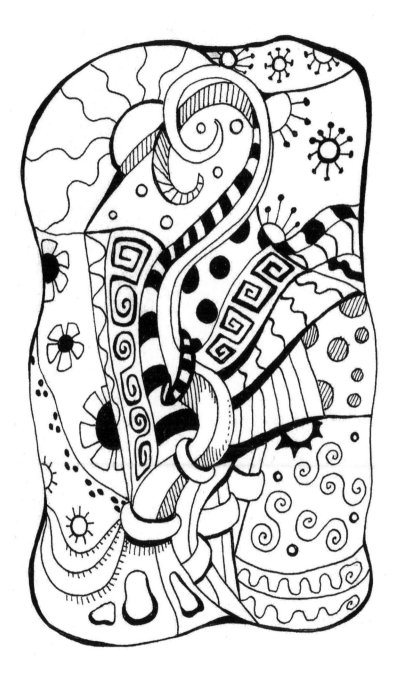

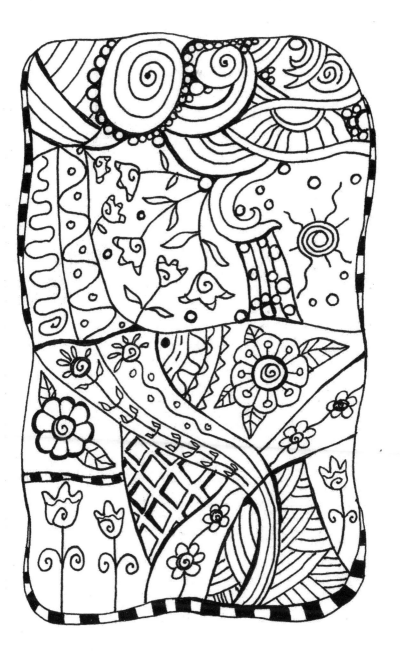

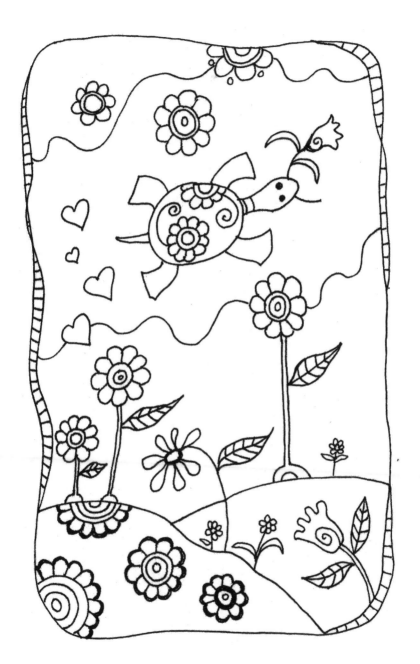

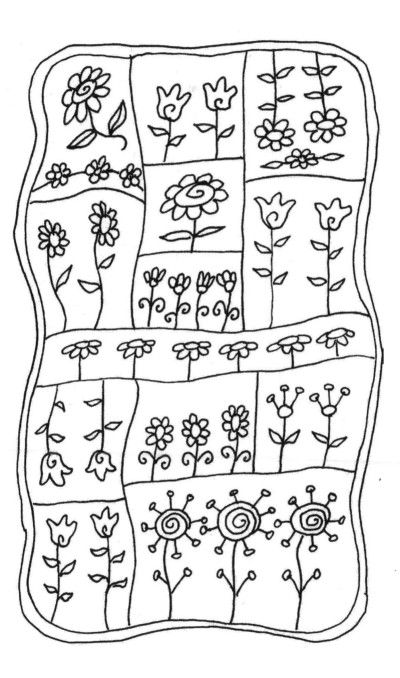

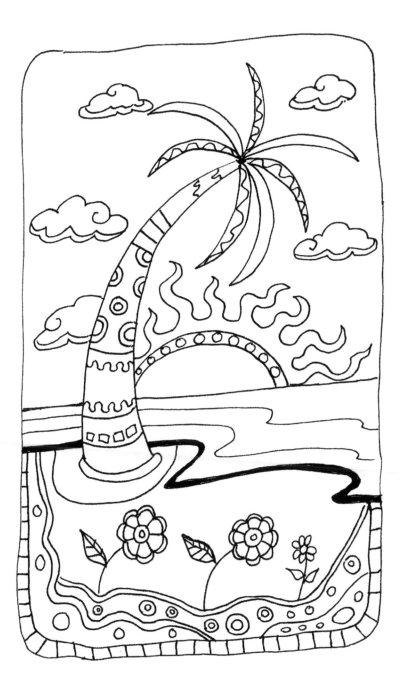

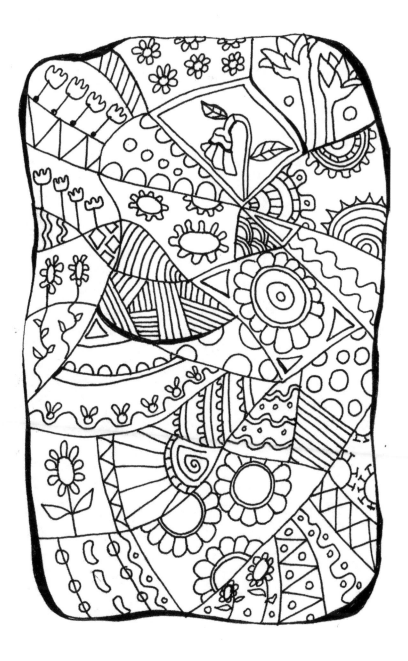

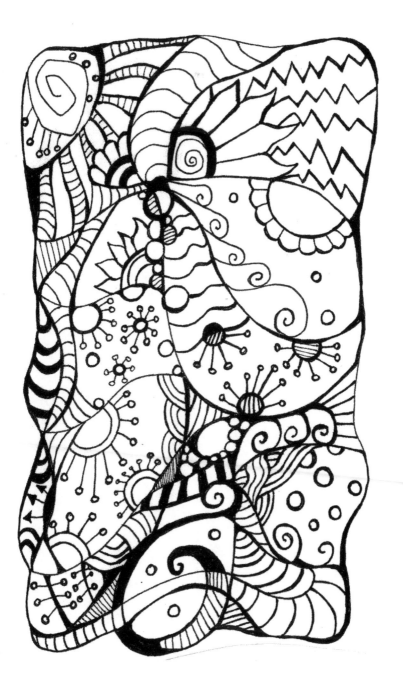

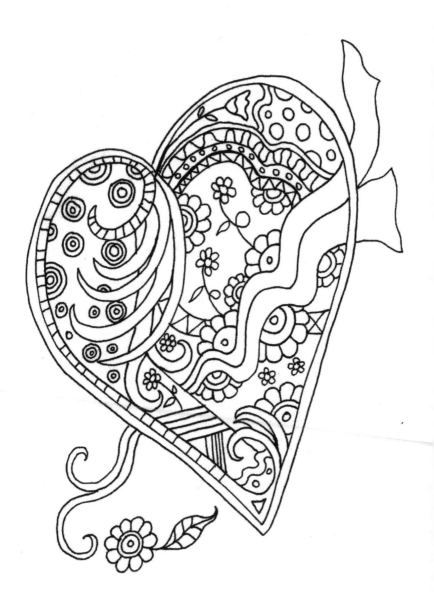

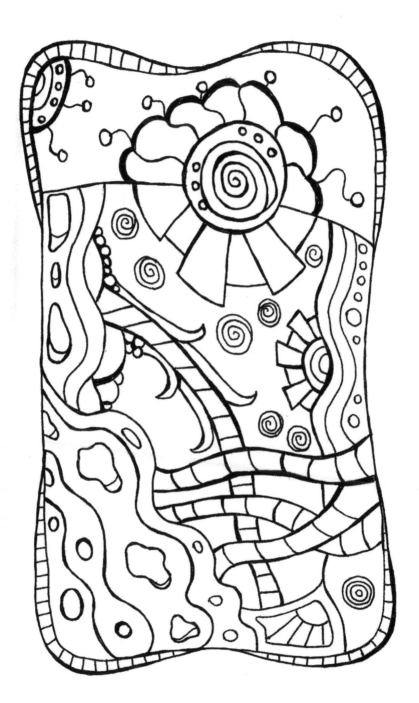

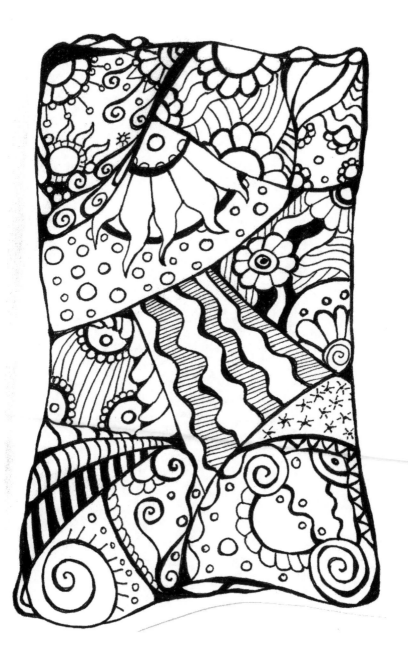

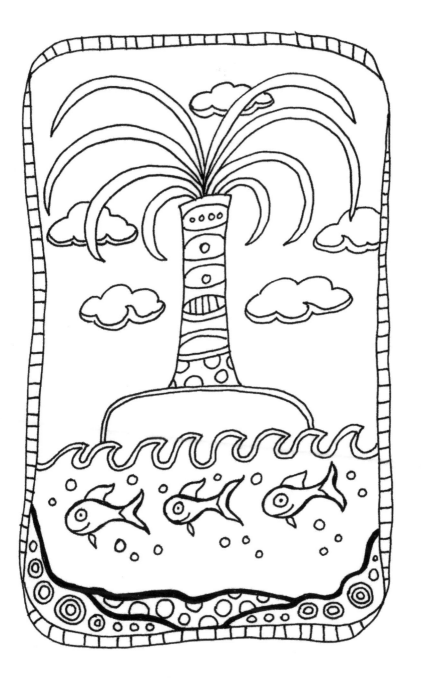

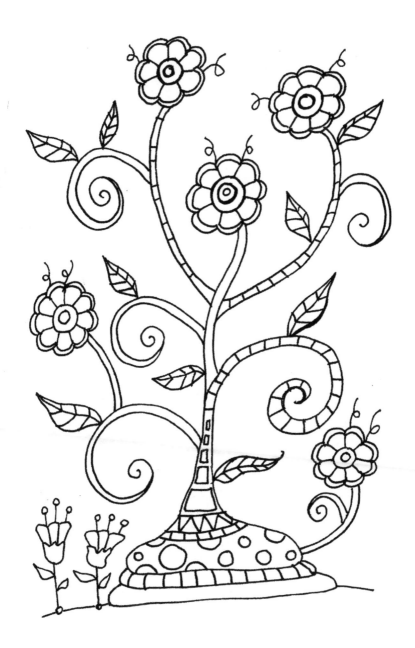

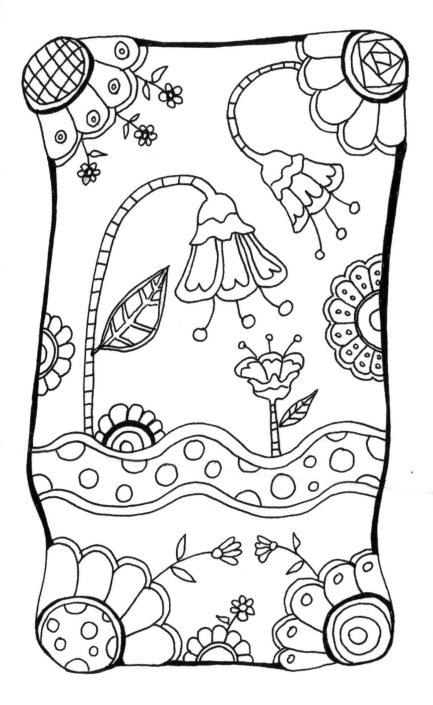

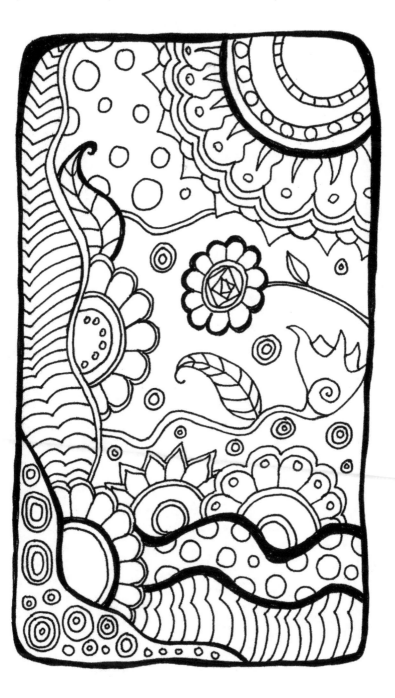

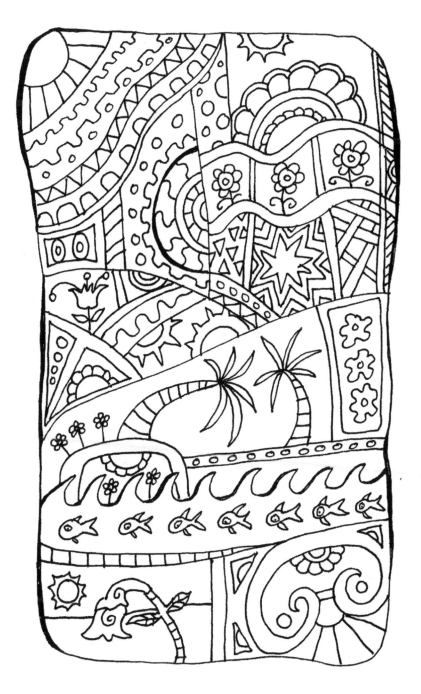

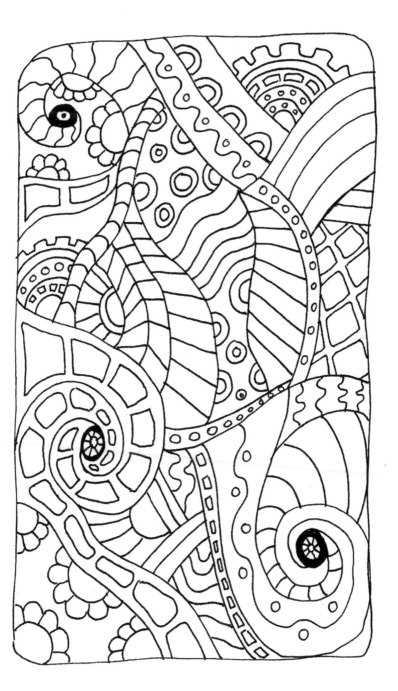

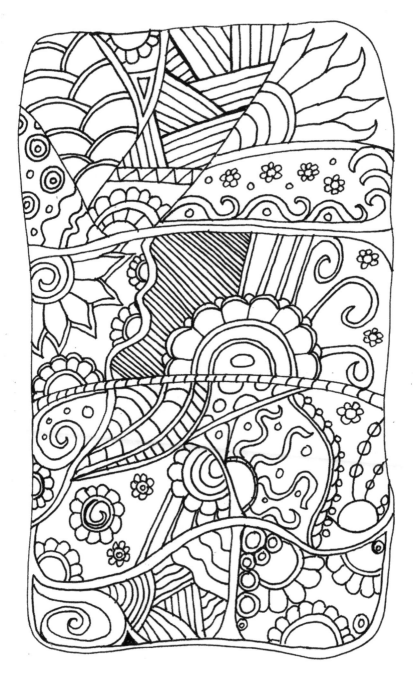

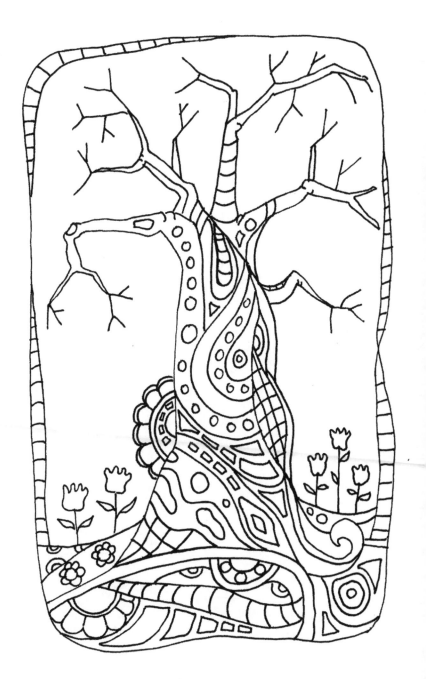

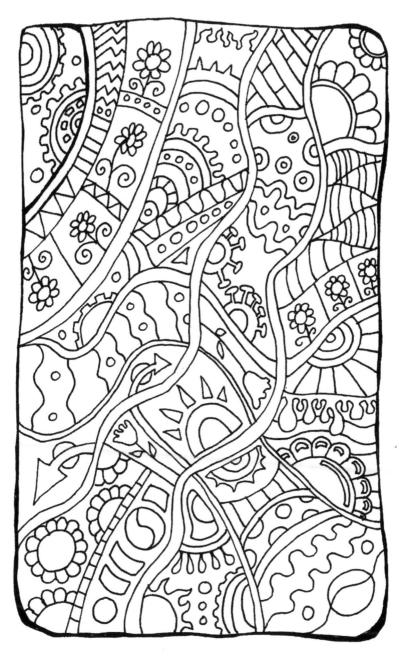

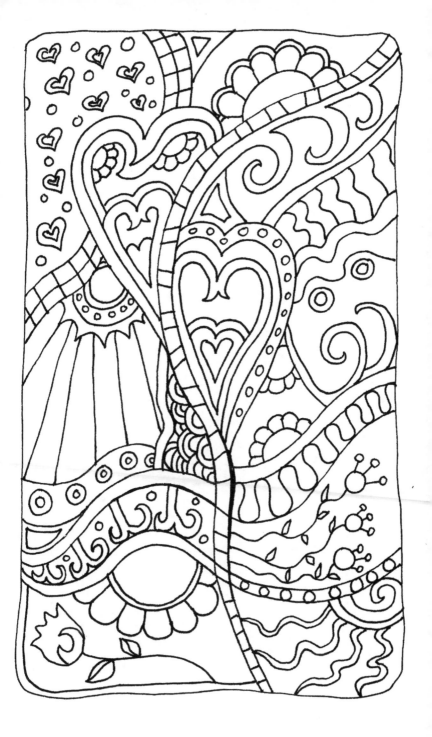

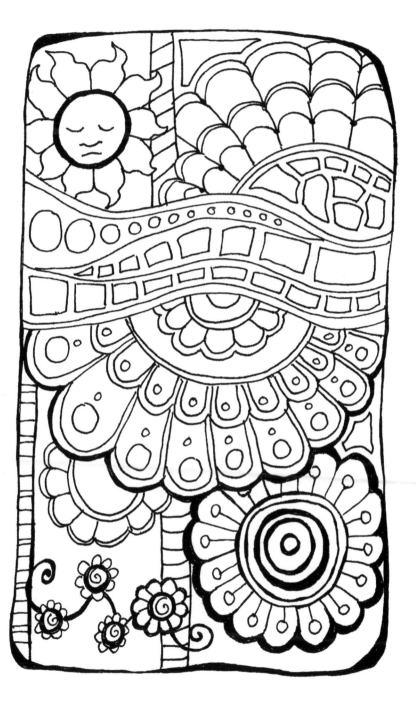

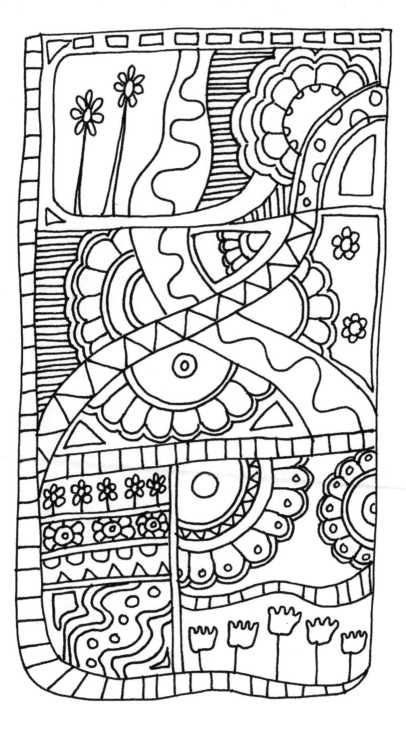

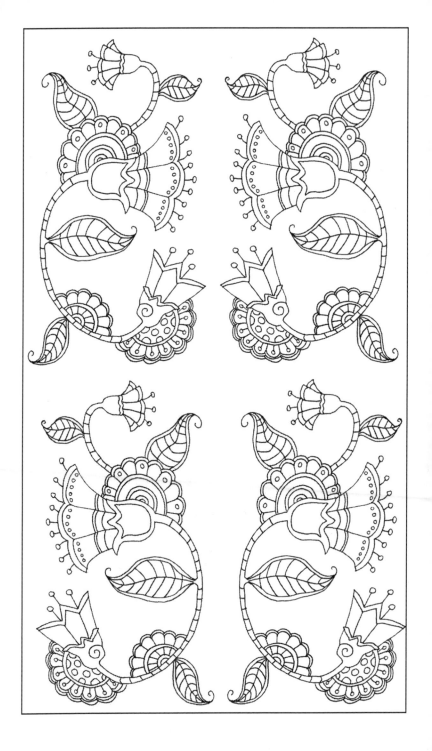

Protection Sheet

Place this sheet of paper

between pages to prevent bleed-

through with markers.

Protection Sheet

Protection Sheet

Place this sheet of paper

between pages to prevent bleed-

through with markers.

Made in the USA
Lexington, KY
10 July 2015